WHISKEY & ROBOTS

by
Bucky Sinister

GORSKY PRESS
LOS ANGELES • CALIFORNIA
2004

WHISKEY & ROBOTS

copyright © Bucky Sinister, 2004

"The Other Universe of Bruce Wayne" was previously published in *Spork Magazine*. "The Other Universe of Bruce Wayne" and "My Date with Wonder Woman" also appeared in *It's All Good* (Manic D Press, 2004).

ISBN 0-975-3964-0-4

Gorsky Press
PO Box 42024
LA, CA 90042
www.gorskypress.com

DEDICATION

These last two years have been another life for me. Big thanks to everyone who made it possible. I can't thank you all here by name, but I'm going to single some of you out the best I can: to Lynnee and Machiko for helping me out in the beginning; to Michelle Tea for taking me on tour; to the Spanganga peops for the stage time, the encouragement, and the confidence; and to the Tsubi Crew for making me feel like a rock star. Thanks to BNO for reminding me that sobriety is fun, to all the FTM's for reminding me that being a boy is fun, and to the Suicide Kings for reminding me that poetry is fun.

This book is dedicated to those who still suffer.

ALSO BY BUCKY SINISTER

BOOKS:
King of the Roadkills (Manic D Press, 1995)

CHAPBOOKS:
Tragedy and Bourbon (Kapow!, 2001)
Nascar: Jimmy Jazz Teabag Series (Jazz Shack TeaBag Press, 2002)
Blackout Poems for Drunk Readers (Self-Published, 2002)
Angels We Have Heard While High (Self-Published, 2003)

CONTENTS

DROWNING ON GOD'S URINE

And the Lord said unto Cain,
Cursed ye be
for ye hath made the ground
drink of the blood of thy brother
spilt by your own hand.
A fugitive and a vagabond ye shall be
all thy days.

And Cain did reply,
Lord, this burden is too much for me to bear.

Whenceforth did the Lord
unzip his holy pants
and pee into a bottle.
When the bottle was filled
with holy golden liquid
he gave it unto Cain
and said,
Cain, this is bourbon whiskey.
Drink of it when you can no longer bear your burden.

I am an organic robot
driven by a tiny driver inside me.

The tiny driver keeps me awake at night
on long crying jags
and complains
about the undeserved amount of disrespect he receives.

I pour booze on him
in a feeble attempt to shut him up.

If you are a bad child in Japan
on Christmas Day all you get

is a twenty-four inch replica of me
during an alcoholic blackout.

The toy of me
does not run on batteries or solar power
but on lunar power
at night it turns itself on
and won't stop talking.
It knows a lot
but remembers nothing.

The toy of me is
the second least popular robot toy in Japan.
The least popular robot toy
has a name that translates to
"The Low Self Esteemed Robot Turkey
Who Needs Lots of Hugs
and Whose Feathers Are Made from
Jagged Metal Bits."

In the anime cartoon
that was made to promote
slumping sales of both toys
both the turkey and I die at the end
when we catch god pissing whiskey from the sky,
can't stop from looking up,
and we both drown.

THE OTHER UNIVERSE OF BRUCE WAYNE

There's an alternate universe
in which Bruce Wayne is poor
and I have my shit together.

Without money,
there's no Batman;
no Batmobile,
no Batcave,
no utility belts,
much less a cool butler and a trusted sidekick.
Without Batman,
there's no crimefighting,
no hot vigilante action,
no pensive brooding on the rooftops of Gotham.
In this universe,
Bruce Wayne drinks alone
in his trailer home in Arkansas.

Bruce has one friend: me.
He calls me in the middle of the night.

"Hey, it's Bruce.
Can you come get me?
I'm feeling real low."

I can tell by the sound of his voice
that he's been dumped again.
In this universe,
Bruce Wayne ain't that lucky in love.

I pull up outside his trailer
in my convertible '63 Lincoln Continental.
Bruce makes his way inside the car,
reeking of whiskey and cigarettes.

"She's gone," he says.
"Can you stop by the store?"

When we get to the store, Bruce hobbles in.
His knees and feet have seen better days.
He's got a couple of vertebrae in his lower back
that cracked and healed poorly that gives him constant pain.
He has chronic headaches
that the VA hospital won't do anything about,
they say it's psychosomatic.

I buy Bruce another bottle of whiskey
and go back to my place.
I know that he doesn't want to talk.
He just doesn't want to be alone.
I turn on the TV and we watch as he drinks.
We watch The Tonight Show with Lenny Bruce.
Tonight's guest is Jimi Hendrix.
He's plugging the album he just cut with Miles Davis:
The Kind of Blue Haze Experience.

He's asleep by the time Late Night with Bill Hicks comes on.
During the guest bit
when Richard Pryor's talking about the cure for Multiple
Sclerosis
I hear Bruce talking, unawake, but not rested.
Bruce talks in his sleep
and I would let him
but when he starts screaming
it's not fucking right, it's not fucking right, it's not fucking right,
I have to wake him.

When he finally realizes he's awake,
he instinctively moves for the whiskey.
He's shaking so hard he can't pour it,
so he drinks it right out of the bottle.
I sit next to him and hold him close to me.

"It's okay, Bruce," I reassure him,
"There's another universe out there
in which everyone loves you.
Children read about you in comic books,
adults make movies about you,
and you symbolize justice in human form."

Bruce exhales loudly and looks up.

"And this in this other universe," he asks, "What are you?"

"Bruce," I say,
"Don't you concern yourself
with that."

SAVED

What I remember most
about traveling through the South
with my father when I was a child is
how hard it was to sleep in those cheap hotels
on the unbearable summer nights.

The air conditioners never worked,
just dripped slow
like a diseased metal sore in the window,
rattled like snoring guard dogs.

I'd lie there on top of the sheet
the bedspread kicked to the floor,
trying to kill the one mosquito
that always hid until lights out.

Outside
I could hear drunk adults
fumbling around with the ice machine
and yelling at each other.
Sometimes I'd get out of bed and
spy on them through the window.
I'd wait until no one was around
and my dad started to snore,
then I'd sneak out and get a cup full of ice cubes
to suck on until I fell asleep.

During the days Dad drove with very few stops.
He fancied himself a CB radio expert
made small talk with the truckers and other CB fans.
We listened to baseball games on the AM radio,
and mostly gospel music on the eight track
with a little bluegrass thrown in.

When my father came to town
people came from all over the county to hear him preach.
They crowded up those little country churches
sitting on the floor
standing in the back
outside the cars were packed in so tight
only mangy yellow mutt stray dogs could get through the
parking lot.

The nights were hot and humid
and inside those masonry block walls
the crowd sat quietly, slowly baking.

When he was done the church sang the invitation song
When they sang
earnestly tenderly Jesus is calling
I felt the people tremble

When they sang
ye who are weary come home
I felt the first tears come

and when they sang
calling poor sinner come home
I felt the crowd break like a Mississippi levee.

I asked my father why so many people came
and he said a lot of people need to be saved.

But they came to see him
for the same reason
they went to hookers in Memphis
and strippers in New Orleans and
why they did 130 mph in Camaros on dirt roads and
shot heroin in Dallas and smoked crack in Little Rock
shot craps in Biloxi and ordered useless shit off the TV:

cause they wanted to be saved,
and they didn't know where the saving was,
and tried anywhere they could.
It wasn't the saving they really wanted
it was always something else they could never have

The woman whose husband backed over their kid:
she wants him to stop drinking to kill the guilt

The man whose brother was gored by a bull:
he wants to be able to pay the quarter million dollar hospital
bill.

The Viet Nam vet :
he just wants someone to kiss
the unhealable wound he uses for a face.

I've seen thalidomide kids,
agent orange babies,
and farmers mangled by their own equipment
limbless and struggling to the front
for one little sweatdrop of god's grace,
for one crumb of his infinite mercy to fall from his table,
for one quick grasp to abraham's bosom,
for the relief promised to lepers, prostitutes, and beggars in the
parables of christ

and still I've never seen one of them saved.

As we pulled out of the parking lot,
the gravel rained up in our wheel wells.

They waved, wore unsure smiles;

from the back window, as they got smaller,
they looked like they were on an island forgotten by God.

Later that night
they wouldn't feel so saved anymore
and they would try anything again
they would drink whiskey from mason jars
give money to strangers on the tv
shoot out windows
hang themselves in barns
but nothing ever worked

As my father and I rolled on to the next town
The CB radio crackled trucker's hopes and dreams
bugs kamikazed themselves on the windshield
my legs stuck the vinyl seats
and the nights now
are never as hot
as they were then

THE DAY THE ANGELS DIED

The day the angels died
you called and woke me up.
Call in sick, you said,
we're spending the day together.

You showed up at my house with two coffees and a couple of
trash bags.

This one's yours, you said, iced coffee, black, no sugar. This
bag is yours, too, we're going to the beach.

On the bus ride there, we saw all the angel bodies stuck in trees,
tangled in power lines and sprawled on rooftops. When we saw
one impaled on a church spire, you said, that's symbolic of
something. I laughed so hard I thought coffee would come out
my nose.

The beach was littered with angel corpses that had washed up
from the sea.

What are we doing? I asked.

Collecting halos, DUH.

I tried pulling one off, but the head came with it, and this
marshmallow fluff crap poured out the neckhole and smelled so
bad I thought I would puke.

Dude, that's NOT how you do it, you said.

You slipped a mirror between the halo and the head and it fell
away easily. We filled our bags with halos and left.

The bus driver wouldn't let us back on since we smelled like
angelpus. We had to walk all the way back to your house.

We spent the rest of the day dipping the halos in turpentine to clean them.

What are we going to do with these? I asked.

I dunno, you said.

YOU DON'T KNOW? I spent all day ankledeep in angelcorpse ruining a perfectly good pair of shoes and you don't know?

Hey, you said, I didn't tell you to wear your good shoes.

In the end, we made mobiles and hung them from the ceiling. By then it was late, and we were tired, so I crashed at your place, but when we turned off the lights, it was too bright to sleep.

MY DATE WITH WONDER WOMAN

After a long dry dating drought, I placed a personal ad:

Single white male, 33, seeks independent woman of action.
Imagine a movie in which Pam Grier saves the day and gets the
man in the end. You should be Pam Grier, and I will be that
man. I will be your backseat betty as we ride off into the sunset
on your Indian motorcycle.

So I waited. I heard from the polyamourous wiccan. Then
from the satanic performance artist who was really into
bloodplay. Then, the beautiful artschool girl who said my
picture was hot and her boyfriend thought so too and wanted to
have a threesome and that I should be willing to sign a release
form for the digital video they would make of it.

I was about to cancel my account, give up completely, when I
got in a response, from wwoman@justiceleague.com. *I think
I'm the woman for you,* she said, *I'm of Greek descent but grew
up in Brazil. I moved here as an adult, and, as I am very busy
and very successful in my career, I don't have a lot of time to
meet men.* Sounded good to me. I emailed her my number.

She called me. It sounded really noisy. *Are you calling from
your car?* I asked. *No,* she said, *I'm calling from my plane. So
you're on a flight and calling from that white phone attached to
the seat? No,* she said, *it's my plane. I'm flying it. I use it for
work. But we can talk about that later. I'll be in town tonight,
let's go to dinner.*

When she showed up, I was stunned. She was built like a
1940's pinup model with this more innocent Betty Page kinda
retro look. She ordered the steak, rare, and ate it casually while
she regaled me with tales of adventure. We got along famously,
and after dinner she invited me to her place for a nightcap.

So as she's making drinks, I'm checking out her library. Mostly books on criminal law and true crime. Not really my thing. Next to the books are pictures of runways and airport hangers with nothing else in them. *What's with these pictures*, I asked. *Those*, she said, *are my plane*. Then she laughed and said, *my plane is invisible*. I'm the only one who can see it.

There had to be something. I can't fall for a sane woman. I've put up with JFK conspiracy theorists, believers of fairies and elves, new agers who read auras, and girls who think Morrisey is singing about them, but never have I put up with an imaginary plane.

Look, Wanda, I said, *it's getting late, and I have to get going.*

It's not Wanda, she said, *oh, forget it.*

I'll call you, I said, turning for the door. But then I stopped, unable to move. I looked down. There was a rope around me. Wanda had lassoed me. She pulled me close. *You don't have to call me*, she hissed in my face. *Don't say you're going to call if you're not going to. You don't have to call me, the only thing you have to do is tell me the truth.*

NASCAR & NOTHINGNESS

Elvis may or may not be dead,
But there's no doubt about Dale Earnhardt.

I had a girlfriend from New York.
She once referred to my family as rednecks.
"Don't call them that," I said.
"But you call them that," she replied.
"No, I call them hicks," I corrected.
"What's the difference?" she asked.
"Hicks go to church,
and won't laugh at a dirty joke
even if it's funny.
Rednecks go to honky tonks
and laugh at every dirty joke
even if they don't understand it."

She claimed it was a class difference,
but I tried to tell her it was a religious difference.

Hicks are religious;
Rednecks are spiritual.
In the religion of hicks,
they follow a strict set of rules
governing what they can or can't do.
In the spirtuality of rednecks,
no one can tell them what to do.
They will do what they want.

I know about both,
having been each one
at different times in my life.

When I stopped going to church
and started drinking whiskey

I changed from being a hick
to a redneck.

My family were hicks
but really close to rednecks.
For awhile
we raced stock cars
but never on Sunday.

My cousin, Rob,
and my Uncle Gene
used to run their cars on a mile dirttrack.

I used to stand in the pits
keeping time with a stopwatch.
The noise was so loud
I couldn't hear anything.
This is the first paradox
of car races.
I communicated with hand signals
to my Uncle, my cousin, my father,
and whoever else was there.
The rest of our lives washed away
and we became the keepers of the secret
that rednecks meditated to find.

The engines of our cars
were tuned to hum mantras as they passed the stands.
Om...om...om...

The rednecks
listened, watched, and slowly got fatter
like Buddhas drinking beer from plastic cups

Whereas the Gautama Buddha had a bo tree
to sit under endlessly
and wait for enlightenment

Rednecks have the couch
to sit on endlessly
holding the remote
like a lotus flower.
They may appear to be watching cable
but if you ask them what they are watching
they will say "nothing."
They are waiting for enlightenment.

When you watch
NASCAR on TV
and they show the cars together
relative to each other
they look as if they are standing still
when in fact they are moving at top speed.
This is the second paradox of car racing.

I had a girlfriend raised by hippie parents in California.
She had never been to the South before
until I took her to a family reunion.
She had been all over the world
except to the middle and southern parts
of her own country.
She broke up with me after a year
because we weren't moving forward
or going anywhere.

If you take the train out of San Francisco
to the Bay Point stop,
you can stand on the platform
and see the Midwest.
It starts there and continues until
the westernmost part of NYC's subway.
Between those two places,
according to Californians,
are farms, Chicago, and truckstops.
If you ask them who lives there,
usually they'll answer, "rednecks."

Their mind fills with images
of *The Beverly Hillbillies*
and the assrapers from the movie *Deliverance*.
Usually they've never been there
nor do they watch NASCAR.

People who never watch stock car racing
think they know why everyone else watches stock car racing.
This is the third paradox of car racing.

They will tell you the only reason people watch
is for the crashes,
and refuse to believe anything else.

When Dale Earnhardt died
Rednecks all over the country
cried as they hadn't cried
since Elvis was reported dead.

Any Redneck who wasn't already crying
started to at when they heard
Classic Rock stations
play "Freebird" in tribute.

I had a girlfriend from the San Fernando Valley
who had never heard a Lynyrd Skynyrd Song before.

When I left her,
I played the Skynyrd song "Tuesday's Gone"
every day for months
and cried like an Elvis fan at Graceland.

On some plane of reality
Dale Earnhardt drives around a track
for all eternity, forever turning left and
laughing at a dirty joke
he heard long ago
but just now understands.

LITTLE KNOWN FACTS ABOUT ANGELS
or
HOW THE DINOSAURS REALLY DIED

I've seen angels
with wings too withered and small to ever have worked
like the extra legs on a sideshow calf.

I've seen angels
in public toilets
tying off with their own halos.

I've seen angels
burning off their wings feather by feather
one hit off the crack pipe at a time.

I've seen angels
with swollen halos, junksick
feeding me lies that tasted like honey.

Angels, like rabbits,
will scream if threatened.

Every time you lean back in a chair
and catch yourself before you fall,
an angel dies.
That feeling in the pit of your stomach
is the sound of the angel screaming.

Angels, like rabbits,
are commonly used in laboratory testing.

Hairspray is sprayed into their eyes
to measure the toxicity.
Angels in the control group
are not allowed to pray.

I've seen angels
with their wings clipped
scratching at phantom itches
in spots they wouldn't have been able to reach anyway.

I've seen angels
hocking their halos
in the pawnshops next to casinos in Vegas.
You can see the halos under glass
next to the wedding rings.

I've seen angels
paralyzed from the wings down
vainly trying to enter churches
that are not wheelchair accessible.

I've seen angels
arsoning bushes
trying to get a hold of
Halo Technical Support
but there's no customer service in heaven.

Most angels that fall from heaven
do not hit the earth.
Fallen angels hurtle through space at millions of miles per
hour.
At night the sun's light reflects off the angels
and they resemble shooting stars.
This effect is called Angelicus Solaris.

The first angel that hit the earth
made a huge crater
and put so much dust in the air
that it changed the earth's climate
and that's how the dinosaurs died.

SOUTH BOSTON, NORTH HELL

I was somewhere in Boston
getting my ass kicked by Catholics again,
hockey style,
where they pull your coat over your head
so your arms are stuck
while they hit you.

At that moment
I imagined
my friends in Arkansas
were getting drunk
losing their virginity
and wrecking hot rods
while I was taking a beating
for something I wouldn't even believe in
two years from then.

I had pissed off some Southie kids
by inviting them to church.
Everyone in our church
was supposed to ask strangers on the street
on a daily basis
to study the Bible with them.
Being fifteen years old, this kind of response
was all too common.

These kids liked to fight,
fistfighting either
like boxers
or hockey players.

When you've been beaten up enough times
your body learns how to go numb on the first hit.
After that you hear the punches
more so than feeling them.

It sounds like dribbling by yourself in a gym
cannon shot echoes
bouncing off the loneliness of your ribcage.

I was taking a beating
that would leave me with permanent hearing damage.

I was taking a beating for Jesus
turning the other cheek
the other eye
the other lip.

I was taking a beating
one in a series of many
and each time
I wanted to be anywhere else
but there was nothing I could do
except listen to the rhythmic pounding
and look down the long tunnel
of my coat.

All I could see
was a small circle
like a searchlight
showing me sidewalk
cigarette butts
and sneakers,
while I looked for some friendly piece of ground
I would never find.

MY GIRLFRIEND IS WAY COOLER
THAN WAYNE GRETZKY'S HELMET

My girlfriend is allergic to peanuts.
If I eat a Snickers bar
and kiss her
she could die.
If I had a venereal disease
and kissed her
she would be really, really pissed off.

My girlfriend will never know the ecstasy
that is a Peanut Buster Parfait,
unlike hockey legend Bobby Orr,
who eats as many as three of them a day.

Hockey legend Bobby Orr
hangs out at a Dairy Queen in Waltham, MA
with Gordie Howe and Eddie Shore.
Together, they act real stupid
and try to pick up girls.

When Wayne Gretzky retired,
Hockey legend Bobby Orr
called him and asked him
to come over and hang out.
But when Wayne Gretzky showed up
they took his helmet
and played keepaway with it
until he cried.

"Don't be such a baby,
stop your crying,"
said hockey legend Bobby Orr,
tossing the helmet back,
"We were just playing."

"I wasn't crying,"
said Wayne Gretzky,
turning to go home.
"I just have something in my eye."

But you can't fool
hockey legend Bobby Orr.
He knows when
you have something in your eye
and when you're crying.

Wayne Gretzky wears his helmet all the time.
Not because he plays hockey, but because
he is terrified of everything,
and the helmet makes him feel safe.
On the plane flight home from Waltham, MA
he held onto his helmet and cried
all the way home.

My girlfriend is not afraid of flying.
If she were in a plane crash,
there is a chance she would survive.
But if she ate the peanuts
that are the inflight snack,
she would die.

I have a recurring nightmare
that my girlfriend and I
are playing hockey,
and I hit her in the mouth with the puck.
But in the dream
instead of a puck
it's a Reese's Peanut Butter Cup
and I accidentally kill her.

TRAGEDY AND BOURBON

Both of my grandfathers left me a gift upon dying.
One, a taste for hard liquor,
and the other,
a taste for tragic women.

When I go to bars,
one eye focuses on my drink
and the other
looks for a woman
who uses ghosts for hairspray
and bad memories for eyeliner.

While I listen to her stories,
I have time to drink.
(I know she will have stories.
Tragic women always do.
They are only looking for someone
who will listen.
When they run out of stories,
they break up with you.)

When I am heartbroken
my mother comes to me in dreams.
She says,
My child, I am sorry,
but you should know better by now.

I know, Mom, I know, I say,
but I couldn't help it.
She looked so sad over there
sitting by herself
drinking her cocktail
so full of stories
I could see the words coming out her pores.

What have I told you? she says.
There are only two types of men
that tragic women will go out with:
abusive men and listeners.

I know, Mom, I know.

And another thing:
stop drinking so much!
My mother's father
married a woman so mean
when she spoke
the snakes in the yard
slithered under the porch
afraid she would snatch them up
and bite them.

I look at pictures of him and his wife
see the scowl she wore
like a halo of dissatisfaction
and the look of contentedness
on his face.
I imagine he had a trick he never gave me
along with the gift,
maybe to have a short term memory
so you can listen to the stories
for the first time
over and over again.

When I am heartbroken
I turn to hard liquor.
The ghost of my whiskey grandfather drinks with me.
He says nothing,
stares ahead with his sour mash eyes,
and lifts his glass
with fingers that have calluses
in the shapes of

Jack Daniel's bottles
and unfiltered Camel cigarettes.

Sometimes it is better to drink with someone
who doesn't talk
especially when you've done something stupid
and don't want to talk about it.

ASPHALT MATADOR

As I sang karaoke
in Japantown

You were thrashing about
on the highway.

Five Detroit bulls ran you down,
left you severed and dying.

You were a matador
matched against life's cruel tricks

With a cape made of
affection for the absurd

And a sword made of
acerbic wit.

We cheered you on
as you made us laugh at our own tragedies.

The day of your funeral
it seemed like the whole world had gone silent.

The crowd emptied the stadium wordless.
The great one was dead.

BLACK ICE AND ROSES

She brings me black ice and roses,
drinks whiskey and coke.
Sipping sweet toxic soda,
I can't give her what she wants,
so I just smile instead,
chipping away sobriety
with my bourbon icepick.

She won't believe me when I say
her time on me
is wasted.

Tonight, I am drinking
with the ghosts of drowned fishermen.
She can't hear them belch up seawater,
she can't smell the dead fish,
but she knows something is wrong.
She asks me what's wrong,
but, before I can answer,
she says, "Never mind,
I've got a full tank of gas,
let's go somewhere
and drink until we forget we ever went wrong."

Later.
The seat of her car
is covered with heartbreak vinyl.
I sit with the window down,
a bottle between my legs.

The end of my cigarette is a sunset
for the microscopic
or for those with low expectations.

I'm blowing smoke out the crack
feeling any words to be
just as meaningful as the exhale.

BLACK SPOTS

The first night I spent with her
she held me and
the black spots went away.
The black spots
that taunt me when I try to sleep
that tell me that
tonight's the night
they're all going to burst open and
I'm going to remember every bad thing I've ever done
tonight's the night
they're going to break free
from the mental prisons I shoved them in
the black spots
floated away like released balloons
went so far I couldn't see them.
She held me and
the black spots went away
I slept
and it felt right to have her there
I slept
and held her close to me.
She was the first person
I wanted to touch me when we slept together.
She was the first one who didn't leave when
she touched me at night
and felt the black spots burrowing underneath my skin.

She had scars
covering the inside of her forearms
(she was an ambidextrous cutter back in her mutilatory prime).
She had scars
from when she wasn't good enough to die.
She had scars
from the punishments she meted out for herself.
She had scars
and I kissed them when we made love.

She had scars
all over
little ones here and there
and I found them all
with my mouth and my fingers
some were too pale to see
but when I touched her lightly enough
I could find them.
She had scars
that I only knew about in the dark.

She pushed me out of her life
slowly
tenderly almost
as if we were dancing.
She pushed me out of her life
slowly
so that I didn't notice it was happening at first
like watching the movements of hot lava.
She pushed me out of her life
and I might have black spots but
she had demons
and they were much stronger than I.
She had demons
and they helped her push me away.

When she was gone
the black spots returned.
They said
we will never leave you
not like she did
we will never leave you
we will visit you every night
and hover in your dreams like rainclouds
we will never leave you
but someday we will burst
and envelope you with your own regret.

When she was gone
a stiffening liquid cold
seeped between my joints
while I tried to sleep
and the only cover I had to pull around me
was a blanket of lies.

FRANK'S DEPRESSION

Frank's Depression
was one scary looking motherfucker.

Wasn't always that way.
When I met him, with his
combat boots
crazy hair
leather jacket
Peter Lorre eyes
New York accent
wasn't anything too unusual for a
San Francisco 1990 style punk rock motherfucker.

Frank was the machine gun of poets.
He could read you 30 poems in five minutes.

"My poems are short," he said,
"Because I don't know many words.
Didn't even know how to read
until a couple of years ago.
Taught myself to read with Henry Rollins' books."

Fortune cookie
word shank
icepick in the kidneys
30 poems in five minutes
in and out
stick it in motherfucker.

Frank started living the squat life.
Scabies and forties
all night cheap crank
penny hustling
anarchy and crowbars
chaos and copdodging motherfucker.

It all started to wear him down,
he lost a lot of teeth
no eyebrows,
looking like a flying monkey with its wings cut off
some kinda Grendel/Mad Max motherfucker.

Frank lived on a diet
of malt liquor and high octane attitude.
Got in a fight one night
with some bouncers in New York
They beat the crap out of him
and threw him out
into the night.
Frank,
drunken and beaten,
bloody and defeated,
found a door way to sleep in.

The next morning,
the cops came to kick him awake.

"Get up, motherfucker," the cop said,
"You can't sleep here.
Get the fuck up, motherfucker.
I said you can't sleep here."

Frank didn't move.

"Oh, fuck!" the cop said.
"We got a dead one here."

GARDEN OF GUTTED BEASTS

The faroff mountains
crawl slowly across the landscape
like rats underneath a bed sheet
more slowly
than the hands of a clock
as you sit by the phone
and wait for a call
bearing the news of death.

I emerge from between my mother's legs
stretch myself out
and hold her on her deathbed.

She tells me her fears
and I tell her it is okay to die.

I leave the room
and in the next 36 hours,
obscenities, profanities, and curses
she has never before uttered
fly forth from her mouth
like the first black feathered angels
released from the pit of Abbadon.
She screams the lyrics
of a gospel record
she recorded in 1957
and it is over.

As I wait
for my hair to fall
my teeth to fall
and for myself to fall for the final time
pulled into the earth
by the unrelenting hand of gravity,

I stand in the garden,
among the corpses of gutted beasts,
who rot without shame or excuse.

I could not express my rage
if I were a field of flowers
with thousands of tiny petal fingers
clenched in tight budfists
swaying angrily at an uncaring moon.

The far off mountains
would think me insignificant
if they noticed me at all.

HOME

Mother was too strong to die quickly.
Her mind blew out first.
She was still barely alive,
her mind running on fumes.

We didn't want her to die in the hospital
so we brought her home
fixed up her room
with a new bed and a morphine drip.

She called to me
and I came in from the West Coast
to be with her.
She had one last request:
"Take me home."

I can't take you home,
this is all that's left,
I'm sorry,
there's nowhere left to take you.

Across the hall,
my father slept in my old room.
It was full of
baseball cards
and hidden vodka pint bottles.

On the wall hung a bat
I played little league with.
On the wall hung a bat
that I kept in the trunk
of the car when I went out.
On the wall hung a bat
that I took to Memphis
when I looked for the man
who raped my cousin.

I wanted to bloody that bat up
I wanted to turn him into a collage
of busted kneecaps and broken teeth.
I looked all over Germantown that night
but couldn't find him.
That bat hung there on the wall
bloodless and clean.

Under the bed
were all my paintings and drawings
my parents were afraid to hang in the house.

I stayed downstairs in the basement
in a small room, the only room
where I couldn't hear my mother die.
The room had no windows
and only a mattress on the floor.
It was all I had left of home.

Home was the props department
of a movie of bad memories.
I had been trying to go home for years
but couldn't find it.
Home was not where I had been.
Home was not where I was.
Home was not anywhere I could go.

I shut the door and pulled the darkness close around me.

Home is a place you run from.
Home is a street you bled on.
Home is a bathroom stall
 you puked and passed out in
 and woke up without your shirt.
Home is the carpet
 that burned your elbows and knees
 the first time you had sex.
Home is the driveway with your handprints.
Home is the drywall with your knuckleprints.

Home is the tree you buried your cat under.
Home is the parking lot
 where your two am whiskey glass landed
 when you threw it at the moon.
Home is the dirt with the worms
 that crawl through the skull
 of your grandmother.
Home is the highway you got so lost on
 you thought you had found
 a rift in the space-time continuum.
Home is the bridge you ran out of gas on
 and waited for the blue eyed man
 with a chainsaw
 to give you a ride.
Home is the river whose black mud
 squished between your toes.
Home is your best friend's couch.
Home is the rooftop at midnight
 the sky blacker than a dead angel's eyes
 your patience shorter than an amputee hooker's stumps
 your life covered with a bad luck leprosy
 your regrets burning inside
 like a self immolating Buddhist monk protesting
 the kind of life and the love,
 the corners of your mind,
 the calls that you made,
 the calls that you missed,
 the quality of time
 and the quantity of kind words
 that you heard
 when you gave it all up
sold it all out

 cashed it all in
 for a pipe dream
 with more holes in it
 than a dead baby
 that's used as a lacrosse ball
 and instead of lacrosse sticks
 everyone plays with pitchforks,

44

and for some reason
you didn't jump.

Home and getting home have been the subject of thousands of
songs.
When my mother died,
she sang a song for her last words.
It was about going home in its own way.
I hope she found it.

A MILLION BUCKS CRYING ON HER FRONT PORCH

I was coming home
a little drunk
singing a song to myself
to cut the cold.

I turned to face my gate,
key out,
and saw a dark figure on the porch.

It startled me.
The porch light wasn't on,
I thought it might be
some freak sitting up there
getting high
waiting for me
or something.

"Oh, hi,"
the dark figure said,
getting up to let me in.

I could see her as she got closer
in the streetlight's glow.
She was one of my neighbors
from one of the downstairs flats.
She let me in.

"Locked out?" I asked.
(One of my roommates had gotten so drunk once
he couldn't work the front door locks
and passed out on the stoop.
This neighbor and her roommate
came home, saw him there,
and took him inside the house.
When he woke up,
he didn't know where he was,

made a quick break for it
and realized he was only downstairs.
We would be only happy
to repay our debt.)

"No, I'm not locked out," she said,
sitting back down.

It was then I noticed she was crying.
She was dressed up,
retro glamorous
to the nines,
like a woman
acting opposite Bogart
or acting in a Hitchcock movie:
tragic and troubled.

She looked like a million bucks
crying on her front porch.
Even with very little light,
her face seemed to catch it all
and reflect just enough
to show her teartracks.

"I'm not usually like this," she said.
She sounded embarrassed,
caught in the act.

"We're all like this," I replied.
"Only some more often than others.
You need an ear?"

"No," she said, "I'll be okay."

And I had no doubt that she would,
but when I got inside,
I said a little prayer to Ingrid Bergman
and Kim Novak
just to make sure.

ONE WAY TICKET TO MIDNIGHT

The clock on the dashboard read
9 minutes to midnight
but we were 10 minutes from the county line.
If we could make it to the package store before it closed,
we would be all right.

God damn it, he said, slamming his fist into the ceiling
God damn it we better make it.

We had a party to get back to, and they were expecting
a case of beer, a bottle of Kentucky Straight,
and a hell of a lot of beef jerky.

God damn it, he said
*If we don't make it we might as well just keep on going
I ain't showing back up there empty handed.
Maybe we'll just keep driving
until we hit California.
Maybe we'll see the ocean
in a few days.*

He reached over,
ejected the Led Zeppelin tape.

*Fuck these guys, you know,
what do they know about not being able to see the ocean?
They live on a fuckin island!
Find something more appropriate*

I looked around in his cassette suitcase
picked out the Heavy Metal soundtrack

IT'S A ONE WAY TICKET TO MIDNIGHT

You seen the ocean right?

yeah I seen it I said

what's it like man?

didn't appreciate it much, I said,
almost drowned actually

Shit, he said, *sorry, I forgot about that*

He slammed down the gas pedal.

IT'S A ONE WAY TICKET TO MIDNIGHT

this is more like it he said
we gonna make it I can feel it

We were cramming 10 minutes of seconds into 9 minutes
worth of clothes
seams straining buttons popping
but by god we were going to make those seconds fit
like pulling corset strings tighter

IT'S A ONE WAY TICKET TO MIDNIGHT

It came to me
that I was constantly in the right place
but always a minute short.
If I could make up for lost time
everything would work out for me
and I could get my life back
the way it was
get a new start
all the rage and the dissatisfaction would wash away
and a peace of mind
would wrap itself around me
like a warm Malibu tide

IT'S A ONE WAY TICKET TO MIDNIGHT

Hey man, he said,
hey man what you thinking about?

Sorry, I said, just
daydreaming.

I was out of the car before he came to a complete stop
up to the liquor store door
as the man turned the lock
and walked back to the counter.

Fuck me, fuck me!
I heard from the car.

I banged on the door.
The guy turned around,
looked at me funny,
unlocked the door.

I was in before he could change his mind
made my selections
took them to the counter
and he said

Remember the time you saved me?

Then I recognized him,
from junior high school,
when he was much smaller.
I had pulled some older kids off him
kept him from a beating.

yeah I said, that was a long time ago, huh?

yeah, he said, *but you saved me that time
and that's why I let you in late.*

I got back to the car
told my buddy
I got my minute back
and made up my mind:
I was going to California anyway
give that ocean a second chance.

RIGHT FIELD

Hey batter batter batter hey batter batter batter

1979. I am standing in right field waiting for a ball that will not be hit to me. In little league, right field is the best seat in the house, but you have to stand in it. Baseball being a game of outs and innings, not minutes and hours, there is an indeterminate time for me to stand here. I stand and wait and watch the game. I stand and wait and watch the crowd. The seats are filled mostly with mothers, sisters, and brothers. The empty seats are filled with fathers who never came home from Viet Nam, with fathers too drunk to show, with fathers working double time to pay off the double wide, with fathers who do not know that on a little league field in Arkansas they have children coming to the plate trying to win their approval one base hit at a time.

No batter no batter no batter no batter

Dewey comes up to the plate. He's going to bunt. We all know this. Dewey has to bunt. Dewey has no arms. Dewey has two hands coming from his shoulders and a sense of self determination that could bend the aluminum bat he's holding to his chest. Dewey plays pitcher: in this level of little league, we use a pitching machine that has a chute to drop the ball in. Dewey leans over the plate. The ball is dropped into the chute. Phoomp, ting, thump. The ball foul tips off the bat and hits Dewey in the chest, knocking him to the ground. The wind is knocked out of him, but he doesn't cry. He never cries. Not when the other kids stick their arms inside their shirtsleeves and sing the Flipper theme song. Not when his father comes home drunk and beats him until he doesn't "smell like Agent Orange" anymore. We've never seen Dewey cry, and sometimes we wonder if he can. Dewey gets up and leans over the plate again.

Swing batter batter batter batter swing

Ten years later I had long stopped stepping up to plates and got caught stepping up to a mirror with two foul lines. My parents took me to both a Christian Rehab clinic and the mental ward. Take our son we don't know him anymore, take our son we don't know him anymore. I'm fending off so many questions and accusations I don't have time to ask why they gave our pregnant mothers drugs and said it was safe, why they sprayed our fathers with defoliant and said it was safe, why they fed us Ritalin like it was fucking pez and said it was safe, why they were surprised that I liked drugs and violent music when they had turned us into a generation of children raised by prescription medication and tv dinners and why they thought the solutions to our problems was to lock us up with prescription medication and food somehow worse than tv dinners, and all I really want to say is mom, dad, don't you recognize me, it's me, the kid out in right field.

SHINE

Lost, broke, and broken-hearted,
I came to San Francisco
a two time loser
of everything I had believed in.
I came to hide
among the wicked and the heathens
but instead
I found the beautiful people
who were a constellation in the city's nightlife.
They weren't celebrities,
would never be famous,
but they knew how to shine
how to take the beauty inside them
and radiate for all to see.
They took me in and took care of me,
called me cabs when I was too drunk,
took me home when I was drunk enough.

They were my angels in Babylon,
saviors in a city of sin,
my guides in a wilderness of decadence.

But, most importantly,
They taught me how to get
everything I never knew I wanted;
they taught me how to use all the damage
that had been done to me
how to use my contusions
to make something beautiful.

Ten years later,
many of them are gone.
Some of them moved away,
others went into seclusion,
and too many of them died.

When the beautiful people die,
I bury them with pride
because the rest of the world
will see it as:
"just another dead junkie"
"just another dead faggot"
"just another dead stripper."

When the beautiful people die
I bury them with pride
because the rest of the world
will say things like:
"He shouldn't have been there anyway."
"She should've known better."
"That's what you get when you pick that lifestyle."

When the beautiful people die,
I bury them with pride
because all too often
their families are embarrassed just to have been related.

When the beautiful people die,
I remember how they knew how to shine.
I try to summon a bit of their brilliance
and carry it with me.

When the beautiful people die,
I celebrate after I cry
for I was blessed with a presence
most were not lucky enough to know.

Scatter my ashes on Valencia St.
where I used to walk like a king
but now I walk as if in exile.

Scatter my ashes anywhere you saw me in this city
but don't let them take a flake of me
back to Arkansas or anywhere else

because if I had listened to them back there and stayed
right now I'd be plucking chickens
or assembling TV dinners
while waiting for the job at the Wal Mart Distribution Center to
come through
and my last thought
after I wrecked my truck
the Steve Miller tape on the stereo still playing "Take the
Money and Run"
the last thought through my Jack Daniel's soaked brain
would be "there had to be something more."

This is the city
where the beautiful people taught me
that it wasn't about finding something to live for
but about finding a way to love to be alive.

Know in your heart
I would be happier dead here
than alive in misery back south.
But until my fateful day,
whenever my beautiful people die
I will laugh with the wicked
I will cry with the heathens
and I will dance for my dead.

THE FACE OFF

One of those nights
no one's around.
Even the pigeons and the rats
have something better to do,
someone to do it with.
I'm a long way from
where I need to be,
a walk where the only people I see
are the ones
who "got something" for me,
who need something from me.

spare a little change?
wanna buy a radio?
spare a cigarette?
you lookin'?
you holdin'?
what you got?
what you need?
what you lookin' at,
whitey?
Fuck you,
white devil motherfucker...

He's drunk
and bigger than I am,
misquoting Farrakahn
and gets no respect
from me
or the Nation of Islam
cuz his malt liquor breath
don't mix with his rhetoric.

I was writing on scrolls
in Ancient Kmet
while you were crawling around

on your hands and knees
in the caves of Europe...

He's drunk
and bigger than I am
fucked up young black man
rage filling his mouth like foam.

He's drunk
and bigger than I am,
looking to fuck me up
and walking by him is my crime.

He's drunk
and bigger than I am,
his words crackle empty
cellophane curses
thrown in my face.

He's drunk
and bigger than I am
If I show fear,
he'll make a move.
If I show my lack of respect,
he'll make a move.
If I stand here
keep my mouth shut
and look him in the eye,
I just might walk out of here.

He's drunk
and wants to fight.
It could be with me
or anybody.
He doesn't care
who I am,
what I say,
as long as he finds how
to get me in his way.
Still I gotta think

would it make a difference
if I were a black man, too?
If he was smaller than me?
If I was drunk?
If he knew me?
If I was with somebody?

He's
taller
bigger
madder
drunker

and I am waiting by a stoplight
that will not change.

I am cold
but do not
zip up my jacket.

I am scared
but do not walk away.

I am lonely
but this guy
does not want to make friends.

Somewhere else,
sometime else
It could've been different.
If it had been
me and him
getting drunk together
on my front porch,
maybe we would've had a good time
and he wouldn't be so pissed off right now,
and maybe I would have
someone to drink with
instead of heading to a bar by myself.

HANGOVER EULOGY

It's as simple as crossing the street sometimes,
unavoidable as bad weather.

You can
look into a child's eyes,
see his dirty hands
many years into the future
grown over with calluses
like the sole of a camel's foot,
imagine his desperate fingers around your neck
as he sits on your chest.
All you can do
is raise a hungover eyebrow
to meet the stare of the little killer
as his mother pulls him
away from you
closer to her.
Her skin: soft and stretched,
Your skin: barely able to contain yourself
as you sit on the sidewalk
and try to ignore the brightness.

It's as quick as a bursting aorta sometimes,
unexpected as soured milk.

On the back of your neck
you feel the wet nose
of a three legged dog
startling you
out of a reminiscent daydream,
causing you
to kick over your 40 oz'er
spilling rabid foam
from its brown-lipped frothing mouth

onto your pantleg
into your peeling leather shoe
as you sit in the park.
The moisture of the grass
seeps into your butt
as slowly as your sobriety slips away.
The dog is friendly and happy
but reminds you
of a horrible beast
who chewed through your throat in a dream.
The dog's owner calls it away
and apologizes
but offers no other consolation
as you walk to the store,
the wind cold as regret
on your backside.

It makes sense,
like a body pulled from the East River, sometimes
foreboding as a three a.m. phone call.

You give a quick glance at the inventory
of a junkie's sidewalk sale
and the familiarity of the objects is haunting.
From the nodding face of the seller
the features of a friend are conjured,
a genie emerging from a needle.
You buy the CD's of bands you saw together,
clench your lover's hand
and fear she is on the same path.
Ten minutes ago,
you had had plenty,
but you go home
and pour another,
from that moment onward
searching the evicted eyes of street people
for recognition of former tenants.

It's unrelenting as a tumor sometimes,
obnoxious as insomnia.

A funeral ends.
You go to someone's house with a group,
even have a good time,
but eventually you have to leave
alone.

It's as obvious as an oncoming train sometimes,
common as saying goodbye.

COLD WAR CHRISTIAN

STEP RIGHT UP
HURRY HURRY HURRY
COME SEE
THE AMAZING INFLATABLE JESUS
AND HIS COLD WAR MARY MACHINE
YOU—WITH THE FACE—

who me

YES, YOU—
COME SEE
THE AMAZING INFLATABLE JESUS

I don't wanna see the jesus

WHATSA MATTER, BOY?
YOU SOME KINDA
COMMUNIST OR SUMPIN?

what's a communist

WHAT'S A COMMUNIST?
DON'T YOU KNOW NUTHIN?
A COMMUNIST IS SOMEONE
WHO DOESN'T BELIEVE IN GOD!

I've met a few bible smugglers:
missionaries risking imprisonment
sneaking bibles into what was then called
"The Iron Curtain Countries."
They had odometers for eyes
prematurely gray hair
kept ulcers for pets
and could lie for Jesus
while looking down the barrell of an AK47.

BOY, WHEN THE COMMIES COME
THEY'RE GOING TO PUT A GUN TO YOUR HEAD
AND ASK YOU TO RENOUNCE YOUR FAITH,
AND DO YOU KNOW WHAT YOU'RE GOING TO SAY?

no

PULL THE TRIGGER!

A family down the street from me
adopted a Vietnamese boy in 1975.
He slept under his bed for six months.
That's what he was used to.
They adopted him for God.
They adopted him for country.
They adopted him because
they were the red white and crucified.

IT'S RIGHT THERE IN THE BIBLE, BOY—
THE COMMIES ARE GOING TO START WW3—
THEY'RE THE DEVIL'S MARIONETTES AND
THEY WANT TO RID THE EARTH OF GOD'S COUNTRY.
AND YOU BELIEVE IN THE BIBLE, DON'T YA, BOY?

yeah

WELL GET ON IN THERE AND TAKE A LOOK!

amazing grace for spacious skies
that saved a wretch like me
for purple mountain majesties
I was blind but now I...

I went down to see my inflatable Jesus
I wanted to touch his ziplock wounds
I wanted to see the shroud Betsy Ross sewed for him
I wanted to ask if they ate apple pie at the last supper
I climbed the Washington Monument
to find my inflatable Jesus

I walked on water across the Delaware River
to find my inflatable Jesus
For forty days and forty nights
I wandered through the Library of Congress
until the Warren Commision appeared unto me
and I surpassed every temptation known
to Senator Joe McCarthy
to find my inflatable Jesus

When I got to my promised land
When I entered my Canaan
When I walked into the land flowing
with milk, honey and the American Dream
I found my inflatable Jesus
But they had filled him too full of lies
and he popped.

THE FIRST THING YOU LEARN
IN THE PSYCH WARD IS WHERE
THE BATHROOMS ARE

I was fifteen
the first time I was there:
visiting hours.
my friend Stevie
said the wrong thing in his psych eval
and got lockdowned by his parents.

He was in a session.
I went to piss,
asked a girl where the bathroom was.

First time here? she said

yeah I said

Men's room is this way she told me
I use it too
there are two kinds of chicks in here:
pukers and cutters.
Girls room is for the pukers;
cutters use the boys's room—
doesn't smell so bad

What's a cutter? I asked.

She held up her arms—
stitches across her wrists.
shoulda cut down, not across she said
I'll get it right next time.

That's a joke, she said.

I didn't know what to say.
Where's your bracelet?
She took my arms in her hands
turned them over
looked at my blank skin
back up at me, confused, asked, *pills?*
I'm just visiting, I said
I don't belong here.

She stared at me suspiciously
with eyes the same color green
they use for church basement walls.
I wanted to walk down into them
and lock them behind me.

She threw my arms down
walked away.
I pissed.
Stevie was ready.
I asked him about her.
Oh, her, she said, *she's crazy.*

Maybe she was.
She may have been the first one I fell for like that
but she definitely wasn't the last.

I'm a sucker for those girls with scars:
scars from falling down,
goodbye-cruel-world scars,
scars on wrists you can read like lines on palms,
and scars deep and raised that you can feel in the dark.

I see those poison ring eyes
and know somewhere she's got them.

There's a cigarette burn in my memory
where her name is supposed to be.

I never saw her again.
Hell, I don't even remember
what happened to Stevie.

He was a good friend.
I loved him.
but Stevie couldn't beat a psych eval
if his life depended on it
and for us back then,
it did.

LOVE SONG

LOVE ME...
Again and again
it came from the radio
LOVE ME...
incessant and taunting
LOVE ME...
but he couldn't turn it off.
He was like a ventriloquist gone mad
unable to put his dummy in the trunk.
LOVE ME...
It screamed at him as he left the house.

He walked to the bar.
Winos and junkies
have boyfriends and girlfriends
but I ain't got shit,
he thought.

Still, he was depressed beyond suicide.
Futility of desire stuck in his soul
like a nail through a voodoo doll.

The wood of the bar
was real.
The stale stench of urine
wafting from the men's room
was real.
The bourbon in his glass
was real.
Everything else seemed
an elaborate con
he couldn't disprove.

He drank.
He tried to remember

how it had come to all this,
what had changed
since the driveway gravel
crunched under his feet
as he ran to his grandmother's arms.
He remembered
the cheese sandwiches and chocolate milk
she made for him.
He remembered
the choking gurgles
she made from her deathbed.
Everything since then was a blur,
but getting drunker by the glass
felt pretty damn real.

He didn't know how long
she had been sitting there.
She had a look on her face
like two thumbs were inside her skull
pushing on her eyeballs.
He could see they shared the same vengeance
when they drank.

He said *got a light*
He said *come here often*
He said *nice tattoo*
He said *I used to like this place*
He said *can I buy you a drink*
He said *can you unhook the vise from my skull*
He said *would you drop an anvil on me*
 put me out of my misery
He said *would you set me on fire*
 kick me out of a plane at midnight
 and let me burn like a fallen angel
 in the night sky?

She said *got a smoke*
She said *didn't I meet you at a party*

She said *is that real leather*
She said *you have a nice smile*
She said *can I buy you a drink*
She said *can you take the icepicks out of my stomach*
She said *would you take a hacksaw to my neck*
 put me out of my misery
She said *would you smear my naked body in chicken blood*
 feed me to stray pit bulls
 and let me be eaten, digested
 and shit into piles all over the city?

Later
at his apartment
the bed
was real
the darkness
was real
and she
was real

LOVE ME...
He heard again and again
but the next day
he couldn't remember
if it had been him, her, or the radio
or all three
in unison.

THE LITTLE CHILDREN WHOM
GOD HATED

I have a friend who calls me
and tells me about her bad dreams.

We were the little children
whom God hated.
To get him back
we stopped believing in him.

(It's the only way to upset
an omnipotent being
that feeds on faith.)

Then the Devil got nervous
Figured he was next in line
so he sneaked up on me
shackled a nasty nightmare to my neck
grabbed me, held me close to him
and hissed,
"You can stop believing in heaven
anytime you want,
but it will take a whole lot longer
to stop believing in hell."

My friend and I
stopped calling them nightmares
and just call them dreams now
we expect them to be bad
and even though there's nothing
we can do or say
to make them go away
the calls are better
than the pills or therapy
that never worked either.

The little children whom god hated
we gather on the playground
where angels fear to fall,
we run phonograph needles across our arms
and listen to the sounds our scars make,
we hold hands so no one
will see us shaking.

Once
I saved my dreams
in a jar under my bed
for a week.
The next time the Devil
came to my house,
I wrestled him to the ground
held his nose shut
and made him drink the whole thing.

When I let him up
he puked
and his eyes watered.

I said,
"See, not so funny NOW,
is it motherfucker?"

JOKER & JUNIOR

During the trailers of the matinee, Joker flips the arm rest up and pulls in close to me. She talks, loudly at first, a tone quieter with each trailer.

I call her Joker for obvious reasons, but I can't always tell when she's kidding. Her setups are always deadpan and plausible, but her punchlines are absurd.

I stayed awake all night, she said. What, you couldn't sleep? I asked, afraid my snoring had kept her up. *No*, she said, *I was reading Irish folk tales to your cyst all night. We don't want Junior to fall behind the other cysts.*

Junior is a dermoid cyst growing subcutaneously on my scalp. We're pretty sure that's what he is. I have an appointment with the dermatologist next week to find out what it is for sure.

If it's a dermoid cyst, it's been there since I was a fetus. Then, it was speck sized and grew as a result of static in the DNA transmission. Every so often it can grow whatever kind of tissue it pleases: hair, teeth, or fingernails. I'm hoping for a tiny eyeball and a tooth, preferably a molar.

The first time I noticed it, I was about four or five years old. I was riding shotgun while my mother drove down a country road. Mom, I said, there's a bump on my head. It's nothing, she said, don't worry about it. That was the last I ever spoke of it to her.

Eleven years ago, Sick Girl noticed it. *What is that?* she asked. It's nothing, I said, don't worry about it. But Sick Girl knows everything that can go wrong with someone. Sick Girl speaks casually of obscure diseases like a grandmother naming relatives no one has ever met. Sick Girl told me diagnoses like they were ghost stories. *Benign follicle cancer. Scalpus*

Gargantuae. Subcutaneous conjoined twin misoplexia. Stop, stop, stop, I said. Sick Girl smiled, then her eyes got big as she said, *I think that mole on your neck has gotten bigger.*

Over the years, I've imagined it as everything from tumor to a homing device implanted as part of a global conspiracy. What if it's a nightmare machine? That little lump cranks out endless devil dogs to chase me in my sleep if I remove it I'll dream a test pattern? Or what if it's my good luck charm, a guardian cyst? What if it's a reset button, when I lose a life, I restart at the previous day with no memory of my death?

My primary care physician winced when she saw it. She didn't know what it was, but set me up with a dermatologist who would remove it. I wanted to ask her if I would have post partum depression. I wanted to ask her if Joker would still love me once it was gone.

The lights dim as the last trailer plays. Joker says in a whisper, *When they take it out, I'm going to keep it.* I wait for the punchline, but this time, I know she's serious.

THE HOUSE THAT PUNK BUILT

All I wanted
was a place to drink
a room to spin me to sleep at night
I wanted to drink
until I forgot how to pray

It had been 15 years
since I stopped believing in god
but upon waking
I still reached for the bible next to the bed
long after it was gone.
I couldn't stop reaching for it so
I put a bottle of whiskey
where the bible used to be.
For the next 15 years,
when I woke in fear of the wrath of god,
there was the whiskey to rock me to sleep,
my golden angel with liquid wings.
It had been 15 years since I lost god
and 15 years minus five days
that I found whiskey.

I found my home
in a house with hot and cold running punks
the ones upstairs
on speed and coke,
the ones downstairs
on vicadin and pot,
and the floor in the middle flat
had the drunken redneck shaped couch
that fit me perfectly

the flat was desolate and empty
quiet enough to die with the stolen cable on
all I had to do was drink and sleep

and wait
but your dog
your broken car alarm of a mutt
upstairs just couldn't keep quiet.

Dying is one of those things
other people make look easy
effortless
like ballet dancers
jumping into each other's arms
I thought I could jete
into the afterlife
from the couch that smelled like someone already had.

Each night I'd pass out
dream of lights at the end of tunnels
all kinds of symbolic shit
felt like it was coming
all I had to do was slide away

then your god damned dog started barking and pulled me back.

Finally I decided it was time to head upstairs and meet this
mutt.

it was all fur and fangs
and so were you.

we yelled at each other
while your dog barked in anti harmony

it was hate at first sight.

Some people
you know right away you're going to be friends with
Some people
you can tell in the first fifteen minutes of talking
that you're going to hook up

And others
you never see them coming into your life at all
until they're there
and you're looking back on years of friendship.

People like us
We have a way of finding each other.

all of us
last chance players
thrown out children
coughed up and spit out
of some small town throat

We hold on to each other

Meanwhile my drinking plan wasn't working very well.
my kidneys liver guts all hurt
I could feel their outlines
Watching TV was hard
Lying on the couch uncomfortable
and walking clumsy

That's not a hangover, is it, you said
watching me walk across the backyard with the grace of
Frankenstein.

you can't fool an ex junkie you said,
I can tell there's something wrong in there

I knew I had three options:
 quit
die really slow and painfully
or help my body die some other way

If you want to quit you told me,
you have to leave this house.
you can't get sober here.
I left.

Found a place across the Bay
took up a diet of Vitasoy, V8, and Ben & Jerry's.
When the whiskey hurts hit me
I ate entire cans of sweet corn,
it's methadone for bourbon drinkers.

back at the house that punk built
someone left some strep germs on the house bong.
Everyone got strep throat
but your system was ravaged from your years as a junky.

They got better
but you never did.

I was in the gym locker room
when they called me on my cell
to tell me you had just died in the hospital.
I didn't know what to do
so I went upstairs and hit the weights
trying not to cry
not because people would see
but because I would drop the weights on my neck.

This song
this obnoxious pervasive pop hit
came on over the speakers,
it was no coincidence, they played it once an hour,
Every rep every lift I knew I'd always associate you
with this shitty Jimmy Meets World sappy piece of shit,
why couldn't I be at a heavy metal gym
so I could at least associate you with a song you liked.

I tried to stay sober,
gave up after your funeral,
got drunk one last time,
and sent you my last blackout as a gift.

I went to visit my neighbors' new baby
too young to talk

with more sober time than me.
soon she'll learn words
whose meanings start simply
but evolve into complexities
words like love, home, and friend
words we can draw pictures of when we're children

this life that we begin with a scream
we end with a whisper
inbetween we gradually lose
the ability to say these simple words to each other

I miss you like whiskey
I miss you like prayer
and when I wake in fear of the wrath of god
you are the only angel I have